POSTCARD HISTORY SERIES

Pennsylvania Dutch Country

ABINGTON FRIENDS SCHOOL
FAULKNER LIBRARY
575 WASHINGTON LANE
JENKINTOWN, PA 19046

The countryside around Lancaster is a tourist destination well recognized in promoting the state. Near the population centers of Philadelphia, Baltimore, and even New York, the Dutch Country is an easy drive. Modern-day visitors are enthralled by the covered bridges, horse-drawn buggies, and prosperous farms operated by the "plain people" without benefit of gasoline, electricity, or other modern conveniences. Shown emerging from the bridge at Soudersburg is a covered buggy, gray in fabric, indicating the Amish sect.

One of the myths concerning the plain people is that they speak a fractured form of English. The conservative sects speak a German dialect at home and in their own communities, High German in worship services, and readily understandable English, which is taught in their schools. Nevertheless, the legend persists. None of the plain people would say "It makes down" in favor of "It's raining."

2

POSTCARD HISTORY SERIES

Pennsylvania Dutch Country

ABINGTON FRIENDS SCHOOL
FAULKNER LIBRARY
575 WASHINGTON LANE
JENKINTOWN, PA 19046

Tom Range Sr.

ARCADIA

Copyright © 2002, by Tom Range Sr.
ISBN 0-7385-0999-X

First printed in 2002.

Published by Arcadia Publishing,
an imprint of Tempus Publishing, Inc.
2A Cumberland Street
Charleston, SC 29401

Printed in Great Britain.

Library of Congress Catalog Card Number: 2001099622

For all general information contact Arcadia Publishing at:
Telephone 843-853-2070
Fax 843-853-0044
E-Mail sales@arcadiapublishing.com

For customer service and orders:
Toll-Free 1-888-313-2665

Visit us on the internet at http://www.arcadiapublishing.com

The visitor is sure to stop at both the roadside stands and the more formal Dutch Country markets that have been operating in the area for decades. The local farmers rent stalls to sell their produce year-round. Members of the families tend market, staffing the stalls to serve the visitors and local townspeople.

Contents

Acknowledgments — 6

Introduction — 7

1. Among Them English — 9
2. Getting Around — 29
3. Down on the Farm — 49
4. School Days, Play Days, Pray Days — 67
5. Homes and Home Industries — 87
6. Impressions — 107
7. Epilogue — 125

ACKNOWLEDGMENTS

In more than a century of their existence, picture postcards have proven to be a fascinating medium for reflecting the period in which they were produced. However, in many parts of North America (especially in the Pennsylvania Dutch Country), changes brought about by modernization have been gradual. The more conservative of the plain people reject, on religious grounds, most modern conveniences and changes in garb.

Most of the postcards in my collection were produced no later than the 1960s, after which the dimensions of the cards were allowed by the U.S. Postal Service to exceed 3.5 by 5.5 inches. Among postcard collectors, these are referred to as regular size. Within the last 30 years, the larger "continental" size cards have been in general production. This term refers to the size of postcards that had been produced in Europe for generations. Until the late 1930s, when color photography was available, the colors appearing on postcards were approximations of reality and, in many cases, fanciful.

The photographers and artists who have documented the plain people for the enjoyment of tourists and postcard collectors deserve mention here and are identified by the publishers who used their artwork: photographers Herbert E. Angell, Marshall Dussinger, Robert P. Frey, Jim E. Hess, Melvin J. Horst, Jerry Irwin, Harry V. Leida, Alice Malone, Richard C. Miller, D. Noble, Edgar Sachs, Vincent Totora, Steven Witmer Jr., and John M. Zielinski; artists Lisa Madenspacher and Jay McVey; and craftsman Aaron Zook for the People's Place of Intercourse, Pennsylvania.

Picture postcard collectors are indebted to these individuals for their work. I am personally indebted to my friends at the Washington Crossing Card Collectors Club in Titusville, New Jersey, for their support and encouragement in producing this book. I express special thanks to Jack Langenfelder of the Millbrook Society, whose participation in the production of Arcadia Publishing's *Hatboro* prepared me for the sometimes arduous task of creating a book. Special thanks also go to Carolyn Wenger of the Lancaster Mennonite Historical Society for her expertise on the religious origins and traditions of the plain people in Lancaster County.

Author's note: Members of the more conservative sects disdain the display of artwork (particularly portrait photography) in their households. Out of respect for their beliefs, care has been taken by the author and publisher to avoid using images that might be considered offensive.

Introduction

Since the earliest days of 20th-century rail and automobile travel, the tourist alighting upon the streets of the urban areas of Lancaster County has been in for a jolt of culture shock. Unless the visitor came from a city and was familiar with the melting-pot commingling of customs of newly arrived immigrants, the garb and accents of many of the passersby would bewilder him. Being referred to as "English" irrespective of his origin would equally puzzle him. The people dressed in what he would consider unusual clothes are the "plain people" of the Pennsylvania Dutch Country. Generally referred to as the Amish, they in fact encompass three major religious sects—the Mennonites, the Amish, and the Brethren (or Dunkard) congregation.

The Mennonite sect, formed in Switzerland in 1525, takes its name from Menno Simons, a Dutch leader who came into the movement in 1536. A breakaway sect, the Amish, was founded in 1693 by Jacob Amman, a Mennonite preacher in Bern, Switzerland. Dunkards are so named for their tradition of total immersion in a flowing stream upon baptism at about age 16. The baptismal candidates are literally dunked in the water. Virtually all of the plain sects are Anabaptists, not following the baptism of infants prevalent in Catholicism and in many mainstream Protestant denominations.

The Old Order Amish tend to be the most fundamental in their religious beliefs and traditions, forswearing most modern conveniences. They adhere to their local dialect of the German language and the mode of dress derived from the German Palatinate in the mid-18th century. To them, anyone who is not "Amish" is "English."

The oldest of the three sects, the Mennonites, settled in Germantown, Pennsylvania, in 1683 to take advantage of William Penn's liberal religious tolerance policies. The Amish arrived in Philadelphia in 1737. The Brethren came in 1719. The term "Dutch Country" is a misnomer; the plain people came generally from Germany and Switzerland, not from the Netherlands. Their dress copies the styles worn in their native regions more than 200 years ago.

Old Order Amish males (both men and boys) wear wide-brimmed hats and black trousers held up by suspenders. Their outerwear is fastened by hook and eye. Buttons are not used to fasten outerwear as a sign of protest against the ornate buttons of the European military, which oppressed their forefathers for generations. Married men are required to wear a beard but no mustache, a practice again rooted in the past when the military wore flamboyant lip hair.

The women and girls in the Amish culture wear similar styles. For both sexes, the basic color is black for outerwear, relieved by brilliant maroons, pinks, and blues of shirts and dresses (all, however, in solid colors). Hidden beneath the women's outer headwear are white head coverings

called *kapps*. These are worn throughout the day by Amish women to hide their hair, a woman's crowning glory. To display one's hair would be vain, and vanity is a sin. The shunning of anything worldly is a tenet of the Amish religion.

Although the plain people do not hesitate to use modern public transportation to travel outside their communities, the ownership and operation of an automobile is forbidden. Gasoline-operated farm equipment is similarly forbidden. Virtually every technological improvement in farming over the last 200 years has been ignored by the plain people. Yet their farms prosper as a result of endless days of toil and a lifelong dedication to farming as a religious vocation.

Picture postcard representations of the Pennsylvania Dutch Country have existed for about as long as postcards have been allowed to pass through the mails at a rate less than letters—that is, since 1898. I have chosen early images, which contrast plain visitors to urban areas, particularly Lancaster, with the English residents of the cities and towns. Virtually all of the views date from before the 1960s. In some cases, more modern cards reproduce photographs taken years before. Since the clothing styles and farm equipment have changed little from one generation to the next, these views are virtually timeless. Throughout the book, I have used the term "English" when referring to people who are not plain. I have used the term "plain" to denote the more conservative adherents of the major religious congregations.

One street scene of Lancaster shows family buggies lined up along the curbs and filled with produce. Although it is a view from *c.* 1920, a modern view would look much the same—rows of buggies laden with produce on Market Day. These two-seated, closed vehicles serve as produce wagons during the week and as family recreational vehicles at other times. One-seated topless buggies are preferred by young men of courtship age.

Of the hundreds of different views of Pennsylvania Dutch Country, most depict action farm scenes. Although these cards show the current way of life for the Amish, they also picture horse- and mule-drawn implements that have long been relegated to farm museums. Like other regions populated by the plain people, this section of Pennsylvania is truly a living museum.

A careful study of the images on the postcards (particularly of the vehicles) discloses many differences in traditions and teachings among the sects. One sect allows only the color gray to be used in fabric for their closed buggies; another uses black. One allows windows in the fabric panels; another does not. Even the style of windows differs. Oval shaping is allowed in one region but only rectangular shapes in another. The courting buggy must always be topless, in all weather conditions, according to one tradition; a convertible top is allowed by another.

These differences in detail are put aside when disaster strikes a neighbor, whether he be Mennonite, Amish, or English. The rebuilding of a barn lost to fire brings out every able-bodied neighbor in the district. Close inspection of barn-raising views discloses Mennonites in their snap-brim hats, Amish in their round brims, and English, often using power tools, dressed any way they prefer. With the cooperation of all, the job is done, usually within a day.

The Pennsylvania Dutch Country is a fascinating section of America to visit. However, it is not a theme park, and the people are not costumed actors. They are individuals living their lives and worshipping their God as they see fit.

One
AMONG THEM ENGLISH

Visitors to the Pennsylvania Dutch Country are welcomed by an uncommon sight—the use of horse-drawn vehicles along paved streets with restrictions for automobile traffic. This view shows a horse-drawn family buggy being maneuvered in what would be a parking area of an in-town store. There is a yellow dividing line on the suburban street, and an electric light marks the entrance—commonplace things to the English visitors but far less common to the farm-based plain people. (Artwork by Madenspacher.)

MARKET DAY ON EAST KING STREET, LANCASTER, PA.

A dynamic street scene takes place in Lancaster on Market Day, when hundreds of farmers' buggies are emptied of their produce for sale to the townspeople and tourists. Note how the shafts of the buggies have to be elevated so as not to block the rails of the trolley cars along East King Street.

Mennonite and Amish People of Lancaster County, Pa.

A man leans against a mailbox on its stanchion at the curb as three women balance their purchases. The headgear of the woman on the left could indicate that she is of the Mennonite sect.

10

The little Amish girl seems to be enthralled by the strange wonders of the city, so unlike her simple life on the farm.

Another family is about to pass an English pedestrian who is wearing a fashionable straw boater.

11

AMISH FAMILY, LANCASTER COUNTY, PA.

This family appears to be a mother and her two unmarried sons. There is no indication of a beard on the older boy. Note the 1930s automobile in the background and the mounting block at the curb near the utility pole.

AMISH FOLKS AT LANCASTER, PA.

A view of a favored street corner shows plain and English pedestrians crossing the city street paved with Belgian blocks. The street features magnificent five-globed electric street lamps and a sidewalk clock rising on its stanchion.

This trio seems to be planning the remainder of their visit to the city. An open-top automobile from *c.* 1920 is parked at the curb.

THE AMISH FARMING PEOPLE OF LANCASTER COUNTY, PENNA WHOSE INDUSTRY AND FRUGALITY HAS DONE MUCH TO MAKE THA COUNTY THE WEALTHIEST AGRICULTURAL COUNTY OF AMERICA

THE DUNKARD SECT, LANCASTER, PA.

This postcard identifies these people as members of the Dunkard sect. The artist has painted the outerwear in brown rather than the black overcoats and shawls worn by the Amish.

13

RELIGIOUS SECTS OF LANCASTER COUNTY, PA. 33760-C

Plain women predominate this sidewalk scene. They could be waiting for their ride home.

MENNONITES OF LANCASTER COUNTY

This postcard, mailed in 1912, identifies the women as Mennonites, gathered perhaps to plan their shopping activities. Most of the plain people wear black outerwear when they leave their farms to go "among them English."

14

An Amish father and son resolutely stride along a city sidewalk in this real photo postcard view.

An anonymous postcard artist has rather crudely altered the photographic view above by removing the boy's arm and adding a mother and child, making these real people caricatures of themselves.

15

A busy urban scene, with the trolley at the intersection, highlights the old-fashioned garb of this young woman and her son.

The photographer has caught a charming scene of a young mother and her two daughters striding down the sidewalk. The children's garb is identical to their parent. (Photograph by Totora.)

16

With bags and parcels filled with store-bought goods, these married men could be waiting for a streetcar. Use of public transportation is allowed by their religion, as long as the trip is not of a frivolous nature.

Two Amish men pass the time in conversation in front of an impressive staircase in Lancaster.

In the top of this split view, the two Amish men might be discussing farm prices in front of the English store with its window display of merchandise and advertising. The bottom view is a typical livestock barn and outbuildings.

Two Amish men are deep in conversation, with womenfolk checking out some goods displayed on a sidewalk table. An English customer and a store clerk turn this commonplace scene into a study of contrasts. (Photograph by Totora.)

Plain and "gay" (meaning members of sects less conservative in their restrictions on garb) Dutch commingle with English neighbors at a country fair. (Photograph by Dussinger.)

This contrast in modes of dress includes Amish gathering together with English visitors to participate in a public auction.

Modern appliances are displayed at a farm sale. The Amish women seem to be intentionally diverting their attention from the stoves and console radios arrayed for inspection. The little ones probably could not even identify these conveniences, which are banned on religious grounds. (Photograph by Hess.)

Amish farmers are keenly interested in this sale of farm equipment. The event is being held at the Old Village Store in the town of Bird-in-Hand, Pennsylvania. (Photograph by Hess.)

20

This street scene provides a jarring contrast between the old and the new. The Amish family buggy is parked in front of a *c.* 1950 Ford automobile.

A family buggy is parked at curbside. Note the special parking area for the horse-drawn vehicles of the plain people. It is set back from the curb line used for automobiles. (Photograph by Dussinger.)

An Amish farmer and young children use the family's courting buggy to pick up supplies in town.

The community of Millersburg, Ohio, provides parking meters for its plain people, who migrated west from Pennsylvania in search of additional farmland.

It is unlikely that these Amish women are conducting bank business. Religious tradition discourages many commercial ventures. They are availing themselves of parking areas in front of the bank building. The absence of street traffic indicates that the scene takes place on an early Saturday morning. (Photograph by Dussinger.)

Another early morning view of the business district of the town shows a handsome bank building. A courting buggy is the only vehicle in evidence, about to pass a gas station available to fill the tanks of the automobiles of the English tourists and townspeople. (Photograph by Horst.)

Another jarring scene to the first-time visitor to the Dutch Country is the proximity of the horse-drawn vehicles to highway traffic. The convertible top on the open-air buggy tends to identify the riders as Mennonites.

A popular tourist attraction in the Dutch Country is the Strasburg Railroad. In this view, a family buggy is parked at the East Strasburg Station. The back of the buggy is opened to display produce available for sale to the English tourists who will be emerging from the train. A small girl on the seat takes her ease as her mother or older sister sets up her display of wares.

A family buggy makes a right turn onto the modern main street of Ephrata (a biblical term meaning "fruitful"). The automobiles date this view to the 1960s. (Photograph by Horst.)

The structure is identified as Mascot Mill, to which the area farmers haul their wheat harvest for milling. This card advertises Dutchland Tours. The firm's tour buses line the street in front of the mill. (Photograph by Horst.)

Her shopping bag filled with store-bought necessities, this woman appears to be waiting to be picked up by her family for the trip home.

An Amish man secures his horse to a curbside hitching rail to run some errands in town. (Photograph by Totora.)

26

Oldsmobile, Lincoln, and Mercury automobiles, along with a tour bus, crowd the parking area of the Amish Farm and House attraction, "the Original Amish Farm Exhibit Since 1955." The family buggy is probably a prop. (Photograph by Hess.)

A huge statue of an Amish man announces the "finest Penna. Dutch Cooking and Baking" to be found within Zinn's Country Diner in Denver, Pennsylvania. In this scene, 1960s cars driven by English visitors occupy the parking spaces in front of the establishment. (Photograph by Hess.)

27

AMISHLAND, U.S.A.

After being immersed in the urban commingling of the plain and English cultures, the tourist's curiosity has been whetted to venture into the lush farmland of the Pennsylvania Dutch Country. This sign caters to the needs of the farming community and to the active tourist trade. (Photograph by Horst.)

Pictured is an artist's embellishment to the road signs found in the Dutch Country. Adolescent titters notwithstanding, the town of Intercourse was probably named for the intersection of two roads within its borders. (Artwork by Steven Witmer Jr.)

28

Two
GETTING AROUND

Nothing is more endearing to view on the road than the appearance of young plain children peeping out from beneath the rolled-up back panel of a family buggy. The young ones always show interest in the cars, trucks, and sport-utility vehicles of the English tourists. Automobiles frequently venture into their rural environment. (Artwork by McVey.)

An Amishman Travels a Pennsylvania Road

There are two basic wagons used on the family farm: the enclosed, two-seated family buggy (above) and the open, one-seat buggy (below). The pride and joy of the unmarried men in the family, the open wagon is generically referred to as a "courting buggy." Two young couples are shown "double-dating." (Photograph below by Dussinger.)

The plain people will have as many children as they are blessed with. Six children would be usual for the average couple. Here, three children peer from the rear of a family buggy, seemingly as curious of the photographer as he is anxious to catch this charming shot. (Photograph by Totora.)

Family buggies form a cortege behind a hearse on its way to a burial service. Burials, as are all other religious functions, are simple ceremonies, without flowers or ornate headstones.

A rarely seen sight is the use of a double team of horses pulling a closed buggy. Their use would indicate the hauling of an unusually heavy load.

A venerable building in the town of Intercourse houses a general store. Note the oil and propane tanks in the side yard. Although religious tradition generally forbids the use of gasoline, propane is increasingly being used to power kitchen appliances that have been converted from electricity-based power.

The covered bridges that dot the Pennsylvania Dutch countryside are favorite subjects of local artists. This view by an unidentified artist captures a family buggy emerging from a bridge.

What appears to be a funeral cortege is caught by the artist H.J. Loewen Sr., with a two-horse hearse leading the procession. (Photograph by Horst.)

33

These two images appear identical, but note the gentleman on the extreme right in both views. The two photographs were probably taken within seconds of each other and produced by different publishers. The views show preparations for an outdoor summer religious service. (Photographs by Dussinger.)

The postcard publisher recycled the image above by replacing the tobacco shed and utility poles with an azure sky. The horse, buggy, and driver remain. (Photograph by Dussinger.)

A parking area for the family buggies is a common sight in the Pennsylvania Dutch Country. The plain people have gathered probably for a county fair or farm auction. The horses still hitched to the buggies indicate a short visit to the site. Note the Chevrolet sedan and pickup truck in the English section of the field. In the background, a vintage automobile drives by the site.

The black-topped family buggy and the church building identifies this group of worshippers as Mennonites. The church building is used on alternate Sundays by two congregations. (Photograph by Horst.)

Further differences between the Amish and Mennonite congregations are found in this view. The Mennonite hats are shaped with a snap brim, similar to a fedora. The family buggies, made with black material rather than the Amish gray, often contain small windows on the sides and rear. (Photograph by Horst.)

The appearance of windows, however small, on an enclosed buggy is a rare sight and is a modification of the boxlike Amish family buggy. (Photograph by Totora.)

A plain community in Missouri allows oval-shaped windows in the enclosed buggies and a more stylized body. The laundry line sports dresses of blue, purple, orange, green, and maroon colors.

A vital industry in the Pennsylvania Dutch Country is the buggy shop in Intercourse. To the left is an enclosed Amish family buggy. In the center is an open-air buggy with a removable top. Old Order Amish would consider the top too stylish for their use.

While the open wagon is referred to as a courting buggy when a young man goes out on a date, it serves as a common utility vehicle in day-to-day life. In this view, a farmer transports his three youngsters to town on an errand.

This view prompts the question "Who has right of way?" Is it the men in the open buggy, or is it the farmer with the team of four horses pulling a farm implement? Smart money would be on the farmer. (Photograph by Horst.)

Another bit of postcard publisher's legerdemain is evident in these two views. The image above shows a courting buggy on a typical country road. The image below (an exact duplicate of the fields, people, and buggy) now contains a road sign blocking the view of the farm buildings in the distance. (Photograph above by Dussinger.)

The convertible tops on these open-air buggies indicate these worshippers are Mennonites, leaving their meetinghouse after services. (Photograph by Horst.)

A rear view of the Mennonite convertible shows the buggies with the tops down. The worshippers are leaving the Weaverland Church at the conclusion of services.

The major difference between the customs of the Kansas and Pennsylvania regions are the double-seated open wagons and the lack of head covering on the three boys. Note the triangular orange triangle sign, warning that the vehicle is animal drawn. These indicators, and battery-operated directional turning signals, are among the few modern additions to the wagons of the plain people.

Two-seated open buggies generally indicate the presence of Mennonites. This gathering is for a worship service in the Canadian province of Ontario.

42

A vital member of a community of plain people is the blacksmith. (Photograph by Totora.)

Another equally important craftsman is the carriage maker, whose skill in constructing and repairing the farm vehicles is valued beyond measure. (Photograph by Horst.)

Snow does not deter the plain people from attending worship services. Sleighs play an important role in community life during the winter months. There are, however, no bells on these sleighs; such trappings would be considered too worldly. (Photograph by Horst.)

Flatbeds being used to haul grain to be milled are being pulled by a double team—horses on the near rig, mules at the building entrance. The wheels of these vehicles do not have rubber tires. Some plain sects ban the use of rubber tires on religious grounds. Some also consider mules (which are incapable of reproducing) ungodly and to be avoided. (Photograph by Totora.)

A barefoot farm boy plays with his red wagon. Although store-bought toys are rare possessions among the young, even small wagons often serve utilitarian functions. (Photograph by Dussinger.)

The familiar express wagon of childhood is put to a practical use as these boys give the little guy a ride on their way home with the groceries. Note the bare feet, a common condition for all children, weather permitting. (Photograph by Totora.)

What is usually considered a child's toy serves a useful function on a farm. It would be used to transport small items, such as the farmer's midday meal, from the house to the fields and for in-town shopping. (Photograph by Dussinger.)

A two-wheeled pony cart, though often a tourist attraction, can play a functional part in farm life. A group of plain children poses by this utilitarian vehicle. (Photograph by Hess.)

46

Another tourist attraction is a ride in a miniature scale-model stagecoach. In this view, plain children are posing with one of these vehicles. (Photograph by Hess.)

Covered wagons transported thousands of families to settle in the American West. The wagons were manufactured in the Conestoga region of Lancaster County. The area is also noted for the growing and processing of tobacco. The term "stogie," meaning a cigar, has its origins as a corruption of the name of the town. (Photograph by Sachs.)

Two young men pose on the cowcatcher of the railroad's "Old 98" locomotive. Note the group of tourists on the left and the front end of the 1960s automobile on the right. (Photograph by Hess.)

A popular tourist attraction is the Strasburg Railroad, which offers rides on steam-driven passenger trains. A group of young plain people poses on the observation deck of the rear car. (Photograph by Hess.)

Three
DOWN ON THE FARM

Artist Lisa Madenspacher captures the simple tranquility of an Amish farm in Leola, Pennsylvania. The watercolor shows a tobacco shed on the left, the barn and grain silo on the right, with the man and boy and family buggy adding a homey touch. A Pennsylvania Dutch Country farm averages about 55 acres, bearing cash crops such as wheat and tobacco and includes sections for vegetables for home consumption and sale.

A classic postcard view is of the solitary farmer plowing his field behind a three-mule team. (Photograph by Totora.)

A mixed team of three mules and a horse pulls this implement, which is being used to ready the field for planting.

A most impressive sight is the operation of a disk harrow, used much like a garden rake to break up clumps of earth prior to planting. This farmer is using a hitch of seven horses harnessed in tandem. (Photograph by Dussinger.)

A plain farmer checks his seed supply on a break from planting this year's crop as the pet dog looks on.

The farmer sits on a corn planter as it is drawn through his field. The corn seed is placed in the metal containers and will be released as the implement passes down the parallel rows. (Photograph by Dussinger.)

This tractor would be used to provide power for the operation of farm implements in the fields. Note that it is powered by kerosene, not by gasoline. (Photograph by Hess.)

A four-horse team pulls this reaper as a wheat harvest is brought in. (Photograph by Totora.)

Newly harvested wheat is pitchforked onto a hay wagon. (Photograph by Horst.)

Father and son are busy with their pitchforks, feeding the newly cut hay into a baler. (Photograph by Horst.)

Young farmers haul a wagonload of hay for further processing. One section of the farm has been stripped of its wheat crop. The adjoining acreage, shown behind the wagon, contains a corn crop. (Photograph by Irwin.)

A hay baler is in use near the dirt road leading into a family farm. The road sign may or may not be the postcard publisher's embellishment to this rural scene. (Photograph by Dussinger.)

Children take a break from tilling one section of the farm to watch the operation of a horse-drawn hay bailer on the adjacent acreage. Most farms produce a mixture of crops: wheat and hay as a cash crop, and garden vegetables for home consumption and for sale. (Photograph by Irwin.)

A stationary steam engine provides power for the operation of a threshing rig. The grain harvesting is an occasion each July. The presence of English neighbors would indicate that the engine is rented for the harvest. (Photograph by Dussinger.)

Bales of hay are being hauled to the barn in this delightful view, with young colts leading the procession. (Photograph by Dussinger.)

Efforts of the entire farm family are employed in setting out tobacco seedlings. The tank mounted in the rear contains water for irrigating the seedlings, which were just planted by the young people riding the implement. (Photograph by Totora.)

Able-bodied family members pitch in to tend the tender tobacco shoots. (Photograph by Tortora.)

The recently harvested tobacco leaves, gently hung on the frame of a flatbed wagon, arrive at a tobacco shed to be air-cured. (Photograph by Dussinger.)

Another step in the processing of the tobacco crop takes place when the harvested leaves are unloaded from the wagon and are hung on the rafters of the tobacco shed for drying.

In the foreground of this farm scene is a hydraulic ram power plant, a simple device to pump water for irrigation. (Photograph by Angell.)

A waterwheel is in operation. As the wheel rotates, a wire is pulled back and forth. This series of wires is attached to a pump handle in the farmhouse many yards away. As the wheel spins, the pump pumps. (Photograph by Dussinger.)

The men workers patiently await the steaming platters of the midday meal to be served al fresco. One of the women of the house pours milk, probably contributed by the family cow that morning. A toddler supervises the setting of the table. (Photograph by Totora.)

Glorifying in the colors of nature, this young plain woman tends to her multicolored flower garden. (Photograph by Dussinger.)

AMISH BARN RAISING

One of the most devastating tragedies to occur on a farm is the loss of its barn by fire. The raising of a replacement is one of the most joyous for the sense of community it entails.

Amish Folks of Lancaster County, Pa., at Barn Raising

In raising a new barn, a true sense of fellowship is manifested in the spirit of cooperation shared by hundreds of plain neighbors of all sects and by English farmers in the region.

This barn-raising scene further illustrates the total community commitment. Seven hundred men participated in the construction, which took only about five hours. The gathered women will prepare a huge meal for their hungry men once their work is done.

At midday, or when the barn raising is completed, the plain women serve lemonade and snacks to the workers. Hundreds of men and women participate in a barn raising, which in most cases can be completed within a day. (Photograph by Totora.)

The 1950s Plymouth attests to the full participation of the English in barn raising. Should an English farm be similarly stricken, plain people would be just as eager to help their neighbor. (Photograph by Totora.)

The man in the foreground employs an electric power saw in cutting lengths of wood for the new structure. Some plain sects use electricity under emergency conditions. (Photograph by Totora.)

The men of the community are perched precariously on the rafters of the barn in progress of completion. Their self-taught skills are highly valued in this close-knit community in which neighbors look out for each other. (Photograph by Totora.)

At least three generations of this farm family set out their tools to harvest the fruits from their arbor. Wooden crates and containers for the fruit juices are unloaded from the utility vehicles. (Photograph by Dussinger.)

Fruits of the harvest are these squash–pumpkins. Some farm acreage is set aside for supplementary crops, which will be sold to local canneries or at the family's roadside stand.

Her chores for the day completed, this little plain girl welcomes back the dray horse to the family barn. (Photograph by Zielinski.)

All is peaceful at Ressler's Mill in Mascot after the day's activity. Amish women, out for a stroll, pass a grazing lamb. Portions of the mill building were constructed in 1760.

Four
School Days, Play Days, Pray Days

In the more conservative plain sects, formal schooling beyond the eighth grade is forbidden. Since the children are expected to dedicate their lives to farming or a cottage industry, no additional education is considered necessary. In 1972, the U.S. Supreme Court upheld the rights of the community to exclude their children from high school education for fear that the mixing of their culture with the English would be detrimental to their religious beliefs. A favored view through the Pennsylvania Dutch Country is the one-room schoolhouse, without plumbing and electricity, in which all eight grades of grammar school are taught simultaneously. (Original watercolor by McVey.)

This postcard view of a trio of plain youngsters dates from at least the 1930s. Yet the style of their garb can be seen at every plain schoolhouse today. The little one to the left wears ankle-length, cuffless, black trousers, open down both sides of the waist, where they are buttoned. The girl's dress is ankle length, gathered at the waist onto the smooth, long-sleeved blouse. If the children, like the adults, are to be out-of-doors for a length of time, they must wear head coverings.

Considering the dour expressions, these scholars are on their way to school. Their lunch boxes are brightly decorated, in keeping with the tradition of allowing utilitarian objects to be embellished "for pretty." (Photograph by Frey.)

A group of English visitors emerges from an inspection of a schoolhouse in Intercourse. The chimney would lead to a wood- or coal-burning stove, the only source of heat in the building. The necessary privy is on the right. (Photograph by Hess.)

A one-room schoolhouse class is generally divided by grade, with the first grade in one row, second grade in the next, and so forth. The teacher need not be plain but has to be talented to teach eight grades simultaneously. The objects on the heating grate in front of the teacher are foil-wrapped baked potatoes that are being kept warm for lunch. (Photograph by Horst.)

The austere atmosphere of the one-room schoolhouse is brightened by the scholars' artwork lining the walls. Note the girls' bonnets on the pegs to left and the boys' hats in the corner, along with the prominently placed baseball mitt. (Photograph by Totora.)

Scholars line the blackboard walls in a one-room schoolhouse. Four of the nine seem to know the answer to the teacher's question. Barefooted boys and girls are a common sight throughout the Pennsylvania Dutch Country. (Photograph by Totora.)

The attendees at a plain school are termed scholars, not pupils or students. These youngsters are enjoying lunch period on the schoolhouse steps. Each scholar brings his and her own meal. Note the girls' hairstyle. All part their hair down the middle and form plaits that ring the crown and are gathered in a bun at the rear neckline. This style is worn by plain women all their lives. (Photograph by Totora.)

Another group of scholars poses before their schoolhouse. These young ones seem to have shed some of their heavy outerwear and lined it up along the building wall. (Photograph by Totora.)

These views of the student body at their one-room schoolhouse appear identical. A closer look reveals the absence of the teacher in the lower image. Both views were taken by the same photographer but published by different companies. (Photograph by Totora.)

72

Athlete scholars call a time-out from a baseball game to pose before the communal privy in the schoolyard. Note the stand of wheat in the adjacent farm field.

A hotly contested ball game works off the energy of these young people. The young fellow in the bib overalls appears to be an English visitor. The lack of indoor plumbing makes the privy a necessity. (Photograph by Totora.)

A teacher serves as pitcher in this softball game. The batter wields what looks like a foam rubber bat in this hazard-free contest. In the background is a large swing set.

A tranquil game of croquet engages the playtime of these young people, with farm buildings evident in the background. (Photograph by Horst.)

These two women appear to be typical suburban mothers. The little ones are more interested in the photographer than in the game. (Photograph by Totora.)

Few buildings contain indoor plumbing. The pump and cistern are the only suppliers of water for drinking and washing. These girls take a break from their chores for some liquid refreshment. More often than not, the younger people are barefoot at school, work, and play. (Photograph by Totora.)

These homemade scooters are familiar to anyone who might have grown up in conditions where money for store-bought toys was scarce. Wheels from discarded roller skates, scrap wood, and a healthy push of a leg are the only parts needed for hours of pleasure. (Photograph by Totora.)

Plain schoolgirls seem to be engaged in a form of ring-around-the-rosey as the boys look on, probably muttering under their breath. The Esso gas station and the utility poles add a modern note to this scene. (Photograph by Miller.)

These young people take a break from school or worship service for a little socializing. Plain teenagers start dating at about age 16. Their dates usually consist of attending well-chaperoned singing sessions, local weddings, and other community functions. After a few dates, provided the chemistry is present, the boy might ask his date, "Do you want to go for steady, or for so?" If the girl replies, "For so," he will have to apply a little more charm to win her over.

Teenage girls pose on an overpass, wearing their traditional garb. Their dresses are of brilliant pink and blue hues. Their aprons are black, and white prayer *kapps* cover their hair.

COPYRIGHT 1906, FRANCES D. CALDER — AMISH CHILDREN OF LANCASTER COUNTY, PA.

The plain children appearing in this 1908 view would hardly appear differently today. Their garb, and even the boy's lunch pail, has scarcely changed over the decades.

Two Amish children enjoy apples, probably grown in their own backyard. The girl seems to be surprised at the interest of the photographer in a normal break in their daily routine. She appears to be holding a piece of fern in her left hand.

On this 1909 postcard, it could be story time for this trio of young people being overseen by an adult member of the Mennonite sect. (Photograph by Malone.)

Children acquire some "book learning" in the outdoors, with a plain farm in the background. (Photograph by Totora.)

Amish girls in their winter bonnets appear to be absorbed in the study of some insects or concentrating on a card game. (Photograph by Totora.)

Two young people, dressed for the winter weather, are ready to enjoy some ice-skating on the family farm's frozen pond. (Photograph by Horst.)

Plain men participate in demonstrating antique sawmill equipment at an annual outing of the Rough & Tumble Engineers in Kinzers, Pennsylvania. English visitors seem enthralled by the doings. Judging by the mound of sawdust on the left, there was an awful lot of demonstrating going on. (Photograph by Hess.)

A gathering at a farm sale affords the young men an opportunity to engage in a game of *mosch ball*, translated as corner ball, a fast-moving encounter where a ball is thrown from base to base. (Photograph by Frey.)

Two plain families, probably on their way to a worship service, are using some modern means of transportation for the little ones. There are no religious objections to the use of modern objects provided they are functional. The red sides on the express wagon and a gaily decorated seat on the baby stroller add a note of color to the black-and-white garb of the men. (Photograph by Witmer.)

AMISH COUNTRY

Old Order Amish worship in the houses or barns of members of the congregation. Services are held every other Sunday. In the vignette to the left of this postcard view, a service is in progress. Plain wooden benches are brought in from a central storage area and set up in the building to be used. The homes of the Amish have at least one interior wall in the form of a sliding panel, which can be opened to connect adjacent rooms. Services last about three hours and consist of Bible readings, sermons, and a form of chanting, all in Old German, a language used only in worship. The upper right view shows an outdoor service in progress. On the lower right, the men of the congregation gather together at a break in the worship.

The Bible is the bedrock of all the religious sects of the plain people. The stricter worshippers use the High German translations of Martin Luther. Among the Old Order Amish, the leaders are ordained from the laity. Each district is virtually autonomous, with a bishop, one or two ministers, and a deacon to lead the congregation. The members vote to fill these offices, with no pay for and no formal training of the appointees. (Photograph by Horst.)

Most of the Bibles used today have been printed recently, but the text and appearance have not changed since the 18th century. Bibles are now printed on more modern presses. The printer is Harry F. Stauffer, who has restored the 200-year-old press at the Ephrata Cloister.

The host family at a worship service is obligated to serve a noontime meal after the three-hour service. Worshippers await the preparation of the meal, all of the males dressed in the formal white shirts and black outerwear. The family buggies are lined up in the front yard parking area. (Photograph by Horst.)

The plain women are somberly clothed in black outerwear at a break in the worship service. The bare tree limbs indicate a fall or winter meeting. (Photograph by Bowman.)

Few if any of the plain sects would allow photographs to be taken of their worship services. This view was carved from wood and painted by the Beachy Amish sculptor and artist Aaron Zook. The Beachy Amish follow doctrines differing from the Old Order Amish. The sect's name is derived from its founder, Bishop Moses M. Beachy, who had served as an Old Order Amish bishop until 1927. (Artwork by Zook.)

The Reformed Mennonite sect accepts formal church services as a part of its religious worship. In this view, a congregation emerges from the brick church building in Brownstown, Pennsylvania. (Photograph by Horst.)

Amish Country

A plain family returns home from worship service, with the males in their formal black-and-white garb and the young mother also in somber Sunday dress. (Photograph by Noble.)

Five
HOMES AND HOME INDUSTRIES

Three feet of Pennsylvania snow blanket the dormant farm fields. The household members would be busy maintaining the farm equipment, canning the fall harvest of vegetables and fruit, and working on quilts both for home use and for the lucrative tourist market. The expanded farmhouse on the left indicates additions during its existence. It is a tradition among the plain people to care for their elderly until death. The addition would be called the *grosdaddihaus,* where the older generation would live under the same roof but independent of the younger family members. (Photograph by Horst.)

Quite naturally, no plain housewife would welcome a photographer into her home to take pictures. However, museums in the Pennsylvania Dutch Country have re-created what would be a typical plain household. This represents a kitchen scene. On the left, a kerosene lamp is suspended over the table, and a wood stove dominates the right-hand wall. The chairs and benches are virtually unadorned. During the winter months, the kitchen would be the communal room for the family. In general, no other room would have a source of heat.

This is another museum re-creation of a kitchen, with a coal stove dominating the left wall and a coal scuttle nearby. No window decorations, such as curtains and draperies, are allowed. Green and blue shades block the glare of the sun. In front of the window rests a treadle-operated sewing machine. The plain housewife is expected to sew all of the family's garments. Note the jars of preserved fruits and vegetables, to be either consumed during the winter or sold at the markets. (Photograph by Dussinger.)

With the winter chores over, this plain family gathers around the kitchen stove for an evening's relaxation of mending, checkers, and reading. The young man is cooking up a batch of popcorn. (Artwork by Zook.)

This is a museum re-creation of a plain living room, which is virtually unadorned except for a decorated child's chair on the lower right and a few handmade wall decorations. The benches in the center of the room are typical of those used for home worship services, when dozens are brought in from storage areas to accommodate the congregation, which can number up to 100 worshippers.

The museum re-creation of a bedroom in a typical plain home is as austere as the rest of the household. There are glimmers of color, but keeping in mind the religious tenet of not being worldly, utility predominates. A quilt is a necessity in an unheated room. It can be fashioned in brilliant colors "for pretty." A doll can be dressed in the bright colors of female apparel. A floor covering can be woven of cheerfully dyed fabric. Note the woman's prayer *kapp* on the cannonball bedpost. Note also the bowl and pitcher and the inevitable chamber pot beneath the bed in this home lacking indoor plumbing. (Photograph by Dussinger.)

A less austere bedroom is depicted in this view. Patterned paper and drapes adorn the walls. An open door to a storage closet reveals a child's sled among the stored items. The bed and other furnishings have gaily colored throw pillows. A rarely seen wall decoration is mounted over the bed. It appears to be an inspirational message. (Photograph by Horst.)

The religion of the Old Order Amish forbids the presence of telephones in the home. Yet, under emergency conditions, their use is allowed. A commercial telephone booth can be set up near a group of farms and possibly on the property of an English neighbor. (Artwork by Zook.)

With the total absence of electric-powered appliances in plain households, the family wash is done by hand and strung on a clothesline to dry. Use of the roofed front porch for this operation would indicate that the weather is threatening rain. (Photograph by Witmer.)

Dozens of plump pumpkins are attractively displayed at the Leroy Pfautz Farm Market in Reamstown. Note the charming displays of the pumpkins propped up in the garden chairs. (Photograph by Horst.)

Dozens of jars of preserved fruits and vegetables, prepared in kitchens throughout the Pennsylvania Dutch Country, are stocked in neat ranks on the shelves of the produce markets. (Photograph by Horst.)

Locally grown produce, both freshly picked and preserved, are offered at a roadside stand. Plain women are not discouraged from this innocent act of worldly commerce. It aids the economy—not only adding to the family funds, but also drawing English tourists and money to the Pennsylvania Dutch Country, to the benefit of the entire community.

A plain woman sets up a strawberry stand on the back of a utility cart along the roadside in Ohio.

Two elderly plain ladies appear to be tending a modest sidewalk stock of potted flowers for sale. Most of the plain sects reject all government aid for the elderly, such as Medicare and Social Security. They take care of the older members of their congregations with their own resources. (Photograph by Totora.)

A *grosdaddi* adds to the family economy by fashioning and selling straw brooms in town. The Texaco station and the folding aluminum lawn chair add modern touches to this street scene.

The skill of candle-making, once confined to the kitchen or farm outbuilding, has been converted into a home industry, where candles are made in quantity for sale to the tourist trade as well as for home usage. In this view, a plain woman deftly operates the apparatus used in small-scale candle production. A batch of red candles is in the process of being dipped. (Photograph by Dussinger.)

A plain girl displays the varied styled candles in stock. She is working at a display table of novelty candles shaped like pieces of lemon meringue pie. (Photograph by Dussinger for the Old Candle Barn, Leola, Pennsylvania.)

Although the clothing styles on the women and children indicate a posed scene, this view illustrates an important home industry among the plain people. Feathers from barnyard fowl can be saved, sorted, and sold as stuffing to pillow and mattress manufacturers. This practice can represent a lucrative source of casual income. (Photograph by Leida.)

Another household skill is applied to a commercial venture. Two plain people are shown operating an apple press to produce cider. The antique press is powered by a 16-foot wooden waterwheel. The girl is filling individual glass jugs from the cask of cider. (Photograph by Hess for the Mill-Bridge Museum, Soudersburg, Pennsylvania.)

This enormous indoor market in Lancaster has housed plain family stalls for more than 100 years. The current building was built in 1889. Earlier buildings dated from the 18th century. (Photograph by Hess.)

Enclosed produce markets dot the Pennsylvania Dutch Country landscape. The younger members of the plain families tend market to serve the interests of the English visitors. (Photograph by Dussinger.)

The reputation of the magnificent needlework of plain women in fashioning quilts has spread far beyond Pennsylvania Dutch Country. Shown here is a demonstration of the art, with participants of plain and English needlepoint experts, at an arts-and-crafts exhibit in Hershey, Pennsylvania. (Photograph by Horst.)

This view captures the communal qualities of a quilting bee. The plain women will spend hundreds of wintertime hours creating these beautiful and useful works of art, both for home use and for sale. (Artwork by Zook.)

A Kansas quilting bee is in progress. Note the style of the women's *kapps*, unlike those worn by the Pennsylvania plain women. (Photograph by Zielinski.)

This quilt has been fashioned by matching scraps of fabric and by hundreds of hours of sewing by hand. (Photograph by Dussinger.)

Dutch Hex Signs

DISTELFINK

LOVE

One of the many myths of the Pennsylvania Dutch Country is the origin of the hex signs. They were never used by the Old Order Amish but were dreamed up as decorations by the less conservative of the plain people. They are meant simply to be decorations and are not meant to offer protection from evil forces.

Dutch Hex Signs

IRISH HEX

GOOD LUCK

A popular souvenir of a visit to the Pennsylvania Dutch Country, hex signs are found in every market and gift shop. This view shows craftsman Johnny Ott and his colorful products. (Photograph by Horst.)

The decorative qualities of the hex sign are displayed along the roofline of this red barn, with a reflection of the building in the adjacent pond.

The craftsmanship of hex sign painter Johnny Ott is displayed for sale to the visiting tourist. Vibrant reds and yellows predominate, with a large green shamrock on the disk in front. (Photograph by Totora.)

By far, the most lucrative of the "home industries" of the Pennsylvania Dutch Country is tourism. Busloads of visitors descend upon the area, snatching up what are offered as "authentic" gifts. This advertising card, issued by the Dutchman in East Stroudsburg, pictures these wares for sale.

A stylized windmill houses Dutch Haven in Soudersburg. Its signage is in brilliant yellow. The advertisement mentions that they "made shoo-fly pie famous." (Photograph by Hess.)

An updated view of Zinn's Diner shows the still prominent position of the Amish man statue. The eatery, now with a well-stocked gift shop and adjacent recreational park, is in Denver, Pennsylvania. (Photograph by Dussinger.)

The Dutch Haven Barn in Intercourse is decorated with barnyard animals, hex signs, and a windmill to catch the eye of the passing tourist. (Photograph by Hess.)

The Dutch Wonderland in Lancaster is a 14-acre theme park with castles, water rides, displays of old automobiles, and more. The attractions are endless. (Photograph by Hess.)

Six
IMPRESSIONS

Over the years, artists have chosen the Pennsylvania Dutch Country for subjects. This is somewhat of a paradox since Old Order Amish forbid any type of depiction of their unique lifestyle. Artwork and, in particular, photographic portraits are to be shunned. As a part of their schooling, the young people are allowed to express themselves in artwork. These plain girls are proudly displaying their art projects, which depict birds and farm animals. (Photograph by David Lauver.)

A tranquil scene belies the humming of activity when this water-powered mill was in operation. The mill owner's home would be adjacent to his mill. (Artwork by McVey.)

Here, the artist has chosen another mill building as an impression of the Pennsylvania Dutch Country. The substantial brick home of the operator is to the right. (Artwork by McVey.)

A courting buggy, with the lush Pennsylvania Dutch Country farmland as a background, is featured in this scene by artist H.J. Loewen Sr. of Leola. (Photograph by Horst.)

This artist captures a similar rural scene as the couple passes a mailbox (bearing the artist's signature) and milk can, set out to be picked up by the local dairy.

110

Artist Jay McVey produced a series of four oil paintings of this covered bridge. *Summertime* shows an English family enjoying a picnic under a tree in full bloom. A courting buggy passes by on the left.

In *Wintertime,* an open sleigh emerges from the bridge, the tree is bare of leaves, and three boys skate (and fall) on the frozen creek.

111

Springtime shows two plain anglers testing their fishing skills in the creek as a family buggy approaches the bridge. The trees are laden with the budding leaves.

Rounding out McVey's seasonal tribute to the covered bridge, *Autumntime* shows a farmer's harvest of pumpkins being drawn past the bridge.

Plaster representations of plain people and a horse are placed around a family buggy to acquaint the tourist arriving in Pennsylvania Dutch Country to the sights he will be seeing. (Photograph by Horst.)

Lifelike animated figures are found at the Weavertown one-room schoolhouse in Bird-in-Hand, as portrayed on this advertising card. The young man in English garb in the middle is passing a slingshot to his classmate.

113

An unidentified artist portrays his impression of a proud plain farmer who is holding the produce from his acreage.

A plain young boy fills a pail at the front yard water pump as a hen looks on. Old Order Amish farms generally have no indoor plumbing.

Milton Denlinger's *Portrait of Amish Boy and His Dog* captures the bonds that exist between the plain people and their farm animals and pets. (Photograph by Hess.)

In contrast to the tranquility of the boy and his dog is this farm auction scene. These auctions serve as a chance to acquire goods at bargain prices and as an opportunity to socialize with neighbors in the community.

This card promotes the theatrical production *By Hex,* presented in 1956 and 1962. It was performed at the Allenberry Playhouse.

This advertising piece for Rutt's Gift and Antiques Shop in Intercourse shows a model of an Amish farm. The back of the card mentions that the farm features an "operating, water-powered grist mill." (Photograph by Horst.)

116

The Amish Farm and House, as sketched by E. Allerton Tobey, is used as an advertising piece by this popular tourist attraction located five miles east of Lancaster.

Designed by E.C. Procter, a view of the buildings from another perspective appears on this advertising card. The artist added a four-member plain family to his impression of the buildings.

The plain people were often and unfairly lampooned in the past for their speaking in broken English phrases. In fact, the plain people are well equipped to converse in their dealings with non-Amish neighbors. The front of this postcard (above) features a cartoon of an Amish family. The back of the card (below) lists the supposedly fractured English phrases used by the plain people. Postcards perpetuating the myth of the Amish speaking style were produced no later than the 1950s.

Greetings from the Pennsylvania Dutch

(Check the appropriate sayings)

___ It wonders me
___ My hair are stroobly
___ The paper wants rain
___ I'm all ferhoodled today
___ My off is all
___ It's wonderful nice
___ Come ahead back
___ It gives everybody welcome
___ I must outen the light
___ Bump, the bell don't make
___ We go the road over
___ It makes down

THE DISTELFINK GIFT SHOP, ALLENTOWN, PA.

POST CARD

PLACE STAMP HERE

Aunt Minnie gets lampooned on these two cards. Obviously, the caption refers to the lady's girth. She is seen peeling apples for a pie or for preserving.

Aunt Minnie accompanies a male member of the family to market in this view. These cards are from at least two different card series, each entitled "The Pennsylvania Dutch," produced by Yorkcraft Pennsylvania Dutch Postcard in York, Pennsylvania.

119

These are further examples of how the plain people supposedly speak poor English. Approximate translations are "The pie is baked. The cake is still in the oven;" "Look out the window and see who's coming in the yard;" and "Yonnie's toe hurts."

This plain couple lives up the road, over the hill at the curve of the railroad track.

120

The publisher provides the translation for the Pennsylvania Dutch term *wutzli* on this card.

"Sneeky" means "snowy" in the top vignette of this card. "Making down" translates to "raining." The young man at the bottom is tying the family dog loosely to give him room to run.

In this domestic scene, a plain farm couple discusses the possibility of rainy weather.

This young man is to throw the hay, not the cow.

The lampooning of fractured English has often been used by commercial ventures. Both stylized Pennsylvania Dutch Country art and language are used to publicize the Pennsylvania Dutch Folk Festival in Kutztown.

Caricatures of the plain people and their supposed English phrases surround this interior view of the Pennsylvania Dutch Room at the Hotel Brunswick in Lancaster.

Seven
Epilogue

Amid the boosterism associated with the Pennsylvania Dutch Country, a visitor is apt to lose sight of what motivates the plain people to disassociate themselves voluntarily from the modern world. It is simply their interpretation of the admonitions contained in the Bible. Their way of life is a vocation, the same in spirit as the dedication of the members of the more formal religions to their chosen acts of charity, in parishes, foreign missions, hospitals, and schools.

Here, craftsman Aaron Zook has chosen as his subject a late-1690s meeting between Mennonite bishop Hans Reist and Jacob Amman, a leader of a dissident group within the sect. The two were unable to settle their doctrinal disputes, so Amman broke from the Mennonite sect. His followers were called "Amish." While relations between these two sects were acrimonious in Europe, they have learned to live together in harmony under the umbrella of religious tolerance in America.

Saal Sisters House and Chapel at the Cloister, Built 1738, Ephrata, Pa.

As the Amish began their settlements in Lancaster County, the German Seventh-Day Baptist Monastic Community was flourishing in the town of Ephrata. The religious community was founded in 1732 by Conrad Beissel. The buildings known as the Ephrata Cloister are now being maintained by the state. Restoration work has been in progress for more than 50 years. This *c.* 1920 view shows the *saron,* or sister's house, which dates from 1743. Note the bell on the rooftop.

A more recent view shows modifications to the 1741 *saal,* or meetinghouse, on the right. Later views show a few of the upper windows being blocked and split-rail fencing installed throughout the grounds.

Throughout the summer months, docents live the life of the cloistered order of past centuries. Here, women demonstrate the art of *fraktur-schriften,* a form of calligraphy.

Male and female docents gather for *vorspiel*, a chanting of sacred songs on the grounds of the Ephrata Cloister.

Aaron Zook entitled this work *Father's Evening Prayer*. The inscription on the back of this card states, in part, "The perfect way to end the day—at peace with God, your loved ones, your community and yourself."